# Phyllis Bramson

## 1973-1986

The Renaissance Society at The University of Chicago    March 9 – April 20, 1986

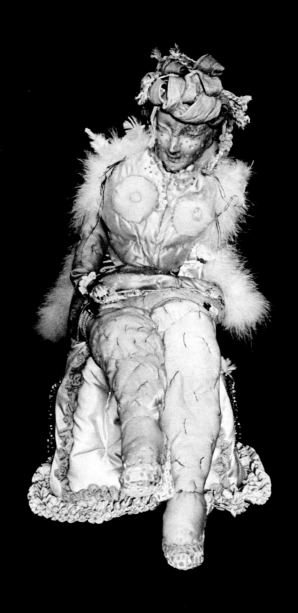

*Carole Doll*, 1973, mixed media, 19" x 10" x 19"

# Acknowledgments

*Phyllis Bramson: Paintings and Drawings 1973-1986* continues The Renaissance Society's important series of retrospectives to honor the work of outstanding Chicago artists. Phyllis's work with its exuberant colors and abundant invented figures, embodies the spirit of independence and innovation. For more than a decade she has worked in the city as artist and teacher developing an impressive body of work which articulates an interior world of intricate emotional experience. This exhibition of work from 1973 to 1986 is presented to acknowledge and celebrate her extraordinary talent and impact on the visual art world.

Our deepest gratitude goes first to Phyllis, for so generously sharing her resources, information, and above all her confidence, which we have felt throughout this project. Not only has she made this exhibition possible, but also most rewarding for all of us at The Society who have had the pleasure to work with her.

We are especially grateful to Dennis Adrian, Chicago art historian and critic for providing a critical essay; to John Vinci, architect and friend, for his assistance with the installation design; to Michael Glass and Michael Glass Design of Chicago for the excellence and generosity in their design work on the catalogue and invitation; to Word City for their careful work with the typesetting; to Meridian Printing of Rhode Island for their production expertise; and to Jim Richerson for his careful and competent assistance in preparing the gallery to receive the work.

Special thanks are extended to the staff of The Renaissance Society: to John Dunn, Assistant Director and Education Coordinator, to Ann Billingsley, Development Coordinator, to Patricia Scott, bookkeeper/secretary, and to Sarah Kianovsky, Adam Finkel, Gillian Ahlgren, Lorraine Peltz and Anne Nie, gallery assistants. Their personal interest and diligent work greatly strengthened the organization of the exhibition, installation and accompanying programs and catalogue.

Throughout, Andrée Stone and Rebecca Donelson of Dart Gallery in Chicago have provided invaluable assistance and encouragement. Monique Knowlton and Pamela Freund of Monique Knowlton Gallery in New York generously offered their resources. I am most grateful for this support.

We are especially grateful for the financial support received towards the publication of this catalogue from Esther and Herman Halperin, The University of Illinois at Chicago, School of Art and Design, Rebecca Donelson, Andrée Stone, Martin Gecht of Amalgamated Trust and Savings Bank, Franklin Nitikman and Adrianne Drell, Naomi and Martin Rubin, Victoria Granacki and Lee Wesley, and Robert Lostutter.

Above all we are appreciative of the cooperation received from the many lenders to this exhibition. They deserve special recognition for their support of the artist, and for their generosity in sharing their works with us.

As always, my deep appreciation and gratitude for their continuing support and trust go to the Board of Directors of The Renaissance Society. I hope the reader will take the time to look through the list of these outstanding individuals from the Chicago community who contribute so generously of their time, energy and resources.

This exhibition and catalogue has been funded in part by a generous grant from The Illinois Arts Council, an agency of the State. Support from the Council has been vital over the last decade, and my gratitude is extended to them. Also The Society extends its sincerest thanks to the Chicago Office of Fine Arts for its CityArts Organizational Challenge Grant award, funded by the City of Chicago.

It brings significant pleasure to The Society and to its membership to present this important retrospective of the work of Phyllis Bramson. We are grateful to have this opportunity.

Susanne Ghez, *Director*

# Artist's Statement

We really face two ways. There is the reality within and the reality outside ourselves. In me, everything about thought is deeply embedded inside an interior landscape — a staged existence where images point to a painter's conflict of needing to put emotion and ideas on display.

There is a legacy of Chicago painters who deal with a psychological figure and space, where fixation is thought of as a virtue, and in the broadest sense the paintings emphasize an emotion rather than reason. They are developed, perhaps, through an urbanized mentality where one can never idealize conditions, where explanations given are stories about transformation and eccentric juxtapositions — narrations of strange intensity where the "nightly dance of day memories" and painted states of being are performed.

I have never objected to being referred to as a Chicago painter. Few artists as their career developed care to accept this identity, but in my studio, smack in the heart of urban Chicago, I feel I continue to carry forward its unique artistic traditions. It also happens that I am struggling with several mysteries of my own — and because I want to remain truthful, every painted gesture, every presentation of luminosity is an act of faith.

While there may be great yearning and fire in my soul, I am fully aware that others may not be set aglow by it. And when I think about that Chicago tradition of powerful and unique imagery, it always makes me wish that I was much better than I am... just because I long for it.

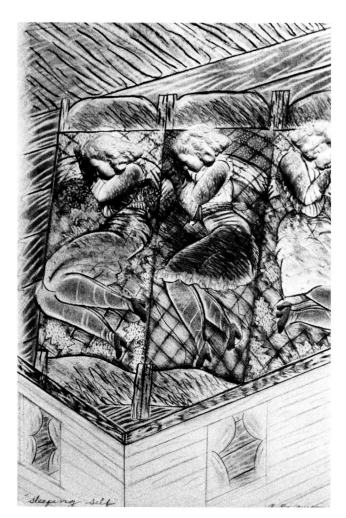

*Sleeping Self,* 1975, mixed media on paper, 50½" x 35"

# Phyllis Bramson: 1973-1986

by Dennis Adrian

Phyllis Bramson's artistic evolution to her present eminence as a painter is not a smooth progress from an artistic identity early recognized and defined which moves straight ahead in a single direction through stages of gradual refinement and increasing expertise; it is rather a diverse development of many fronts, each of which plays a role in the maturation of her art. Bramson's work reflects and draws from her background, her education at the University of Illinois at Champaign-Urbana, the University of Wisconsin at Madison, and the School of the Art Institute of Chicago, her interest in theater, her involvements with many artists who are her friends, her continuous exploration of the psychological components of her own personality and fantasy and, above all, her examination of the condition of what it is to be an artist.

While Bramson has established her reputation in Chicago and nationally as a painter, she has pointed out that although she has, in one way or another, worked as an artist since about 1959, she started painting (in what she considers her mature style) only in 1980-81. Though the origins of her present stylistic direction can be seen to be established by 1973 — the beginning point of the present exhibition — she has said that, "1979 was the time I woke up [to the possibilities of painting]." These remarks reveal a number of important things about Bramson's art and its significance. For one thing, along the path to her present status as a painter, Bramson has worked, in different periods, in a wide variety of media. She has made sculptural works, most notably a series of dolls in composite materials, a number of which are portraits or which have portrait-like references to artists she has known and worked with; complex series of drawings and watercolors; pictorial works involving pastels, colored crayons and pencils together with collage elements; and painting/objects. In this final category, a painting or other pictorial work is embellished by added three-dimensional objects which punctuate the composition at the edge of the frame, on a shelf at the bottom of the picture, as an *assemblage* of objects and construction free-standing in front of a pictorial element, or which make use of all these possibilities.

These activities in a wide variety of techniques seem to have served several functions for Bramson. Each technique and medium (or combination of them) permitted her to explore avenues of imagery and feeling which led to an increasing clarification of her artistic persona and, as well, allowed her to address a variety of artistic and formal issues in a hands-on fashion which had, by design, a number of possible formal and imagistic resolutions. If in some ways this was a hedging of bets, it nonetheless let Bramson gain an impressive freedom in her ability to invent forms and images and to deepen her awareness of just which currents of invention, imagery and content were to be her central themes. To put it another way, the sorts of situations, climates of feeling, emotional concerns, and personae which both inhabit and articulate them — which Bramson now puts forth with such clarity and directness in her current painting — were all born or discovered, as well as developed and proliferated, in these varied earlier works.

It might be said as well that one can sense a certain reluctance on her part to undertake the scale of larger painting in the works before 1979. The artist has said that she realized that the compositional schemae, so successfully evolved to work in drawings, pastels, collages and the like, could not simply be enlarged with the confident assumption that they would be as effective in the larger scale of paintings: for them, new systems of pictorial resolution would be required. Specifically, the spatial construction of paintings in formats of about 60" x 60", which the artist used in the early 1980's, called for a forthright confrontation of the questions of depth and recession which the earlier smaller formats did not present so pressingly. For example, in some works from the later 1970's such as *Still and Not So Still Lives (Shoe)* of 1977, the overall format is divided up into smaller rectangular fields, within which the

5

images float against grounds that have little if any spatial structure: what sense of space there is has been created by the modeled volumes of the images, images that fill a good deal of their separate formats. The organization here reminds one a bit of a similar division into internal rectangular formats employed in an important series of paintings by Suellen Rocca in 1966, where in relatively large formats (about 72" x 66") the problem of organizing the distribution of numerous smaller figurative and emblematic images in the overall field is so handled. In *13 Ways to Live 8 Ways Chosen (Constant Seeking and Devotion)* of 1980, Bramson has dealt with the long narrow format (52" x 20") by drawing upon the systems of Rajput miniatures and Japanese woodcuts, where several spatial zones, each employing parallel orthogonals, are stacked one upon another, the transitions between them being elided by means of repoussoir-like projections of architecture, furniture and the like. Except for the narrowness of the format, like that of the Japanese pillar print woodcuts, the spatial construction is also reminiscent of similar organizational devices in paintings by Roger Brown that appear fully developed in his work by the early 1970's. In these, as in Bramson's paintings, a tension is created between the design of the forms and images distributed over the surface of the pictures and the arrangement of these forms and images understood as existing in space which extends back from this surface. Both artists enhance this tension by having objects and figures, understood as near or far, appear in the same scale.

These systems of spatial and compositional construction, which depend on either subdivision of the field into smaller areas or the orthogonal perspectives related to near and far Eastern art, work very well as long as the scale of the figurative images does not become too large. When the scale of the figure *does* become larger, the artist is faced with several considerations. If the larger figures (or other images) project any sense of volume or bulk, this effect can disrupt the balance and tension of the image and ground described above. The volumetric forms will by themselves appear to displace a certain amount of space, and their nature as images or the actions and situations they describe may imply still more: at this point the compositional structure as well as the imagistic situations will require a new formulation, one which articulates or suggests a space adequate to accomodate the volumetric forms and images. An alternative to this is to renounce a sense of volume and concentrate on forms as areas, with spatial sequences suggested by color, overlappings, or varying scales of the forms and images: this might be thought of as the "Matisse cut-out" solution.

Since Bramson's figural images have remained, since the early 70's, concerned with some sense of volume, new spatial formulations had to be developed for her work to move effectively into the field of large scale painting. Together with a newly clear determination of her imagistic range and its associated content, this confrontation with the issues of large scale figural painting seems to be the breakthrough issue to which Bramson "woke up" in 1979.

In the three part work *Myths of Inspiration* of 1979 Bramson, while still dividing her compositions into areas, constructs deeper spaces, some stage-like in nature, where curtains and other kinds of framing devices open into them and where a more atmospheric use of color, now containing modulations of hue and value which themselves indicate depth, play a new spatial role. This triad and associated works are landmark pictures in the artist's full maturity. The various paintings called *Borrowing From Hockney (but Rejecting His Embrace)* of 1980 show the next steps in developing new structural and organizational means suitable for the increasing scale of Bramson's pictorial ideas: while some compartmentalization of the compositions still remains, there is a new confidence in the presentation of volumes — even faceted ones — and images in different scales. Also, the stage-like tableaux are done with skillful sureness and the scale of the figures (and therefore their emotive potential) has increased. These issues and ways to deal with them parallel developments in Hockney's paintings throughout the 1960's, when he moves from the schematized spaces and flattish figures of his early works to an increasingly solid and emphatic sense of volumes placed in clearly defined, often architectural spaces.

Bramson's development from 1982 to the present shows her moving with increasing confidence and ability into larger and larger formats. In these works, such as *Portrayals and Betrayals Stage 1* and *Existentialist Witness (for P. Adams) Stage 2* of 1982, the figures gain a new plasticity and expressiveness in compositions and subjects of a more dynamic nature than before. The artist feels at ease with the larger formats and bigger scale of her compositions and their protagonists. Very recently, Bramson has tackled some ideas so big that she is obliged to work them as diptychs: the largest of these pairs to date, *Secrets Have Shadows* of 1984, is 6' x 8'. The reason for distributing the composition over two canvases is that the single units represent the largest size that she could conveniently work. Bramson has taken advantage of this situation: while the background landscapes form a continuous scene when the canvases are butted together, each one can operate separately as an integral composition. This again re-

*Baby Heidi Chair*, 1976, mixed media, 35" x 15" x 16"

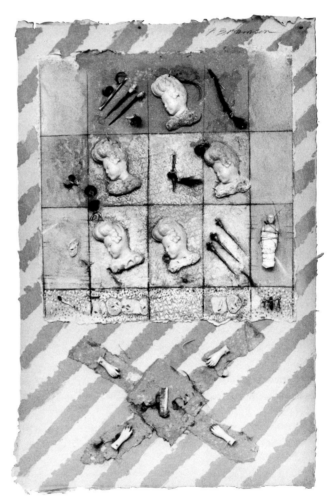

*Trapped (Lady)*, 1977, mixed media, collage and objects on paper, 40¾" x 26¾"

flects the practice of Japanese woodcut designers, whose subjects of two, three, or more blocks can be appreciated individually as well as forming a unified image and design when placed side by side. More recently still, in the very large canvases of 1985 such as *Shipwrecked* and *The Dance* (each 67" x 96"), Bramson has tackled panoramic situations with very deep landscape spaces. In these works the artist disposes her subjects with the greatest freedom and certitude, having established her abilities to compose on a monumental scale.

Bramson's formal evolution thus moves through separate stages of works in different media such as drawings, watercolors, collages, sculptural objects in the form of dolls and ceramic constructions of varying aspect and then into combine picture-cum-sculptural object works in increasing scales until, after a period of retaining some collage embellishments and punctuation, she turns to address the issues of large scale painting in 1980-81. From then to the present the paintings have grown in scale, artistic confidence and expertise to the large, even monumental, works of the present.

There is a development of Bramson's imagery and content as well as an evolution of her means and media through these different stages. The dolls and ceramic objects have the literalness, the actuality of their three-dimensional existence (and portrait character, for the dolls) but at the same time are emblematic, fetishistic, in a way that implies that they stand for something outside themselves. The balance between this literalness and the referential functions in these works is occasionally uneasy and perhaps cannot really be comfortably resolved. Along with other largely technical considerations, this may be the reason why this direction is left behind and a different kind of unity sought in the drawing, watercolor and pastel compositions with divided compositional fields and/or additions of collage and applied objects of 1977 and 1978.

In some of the breakthrough pieces of the following year, 1979, Bramson has begun to feel her oats in larger, more deliberately structured pictorial fields but is not yet prepared to discard completely the actuality of auxiliary and ancillary objects which expanded upon and inflected the pictorial ideas. This is the time (1978-79) of drawings and the like with shelves and associated objects. In fact the shelf additions and free-standing objects with paintings appear intermittently until as recently as 1982-83. Perhaps this stage might be seen as "Eliza with a different ice floe under each foot." The pictorial elements are more assertive and compelling visions, but the artist still wishes them to be associated with objects and images that are "actual," concrete,

and three dimensional. This artistic formulation has certain problematic tensions and challenging complexities. One difficulty, and one that is endemic in the picture-object combination as a work of art, is that the changing (and for the artist uncontrollable) circumstances of the installation setting may, and even almost surely will, from time to time seriously compromise the effect of such a diverse work. This is especially so when the associated object(s) are free-standing; they necessarily become part of the physical environment and so are subject to a number of interactions with it, which cannot easily be foreseen or controlled. Perhaps the only artist who has had a palpable success in this kind of association of object, picture and its setting(s) is William Wiley, but even so, many people have surely experienced the unhappy encounter of a wonderful Wiley work placed in a cruelly and destructively unsympathetic environment. Bramson seems to have struggled with this problem and in some cases, subsequently decided that a number of her combination works could do without their adjunct objects and stand alone as pictorial works, although a number retain their shelf-frames with attached items.

A second issue which the combination works present is the nature of the associated objects. In a number of such works, Bramson has used Art Deco figurines of dancing women. The scale of these figures (and other objects she has used) is congruent with the scale of her figures in earlier drawings and pastels, but, as the pictorial formats increase in size and the figures within them also grow in size and scale, there is an ever greater disparity of scale between the images in the painting elements and those of the object adjuncts, making it increasingly problematic for their expressive relationships and interactions to be maintained in a unified fashion. Then too, Bramson's increasing command over the psychological world of her pictorial statements and the gradual intensification of her themes and subjects in them came perhaps to supercede, through growing authority and sureness, the "actual" functions of the now comparatively small and always problematic object-images.

One of the sources for Bramson's involvement with the picture-combine-object is probably her experience working at Marshall Field and Co. as a window display artist in the period 1966-68. She describes this kind of work as a sort of theater and certainly the tableau aspects of window design merit this comparison. But, in this situation, the window itself is an invisible barrier as is the proscenium in the theater. In such a set up the artist must be both director and audience, but cannot be a participant in the "drama." In her large scale paintings, one feels that Bramson has crossed this bar-

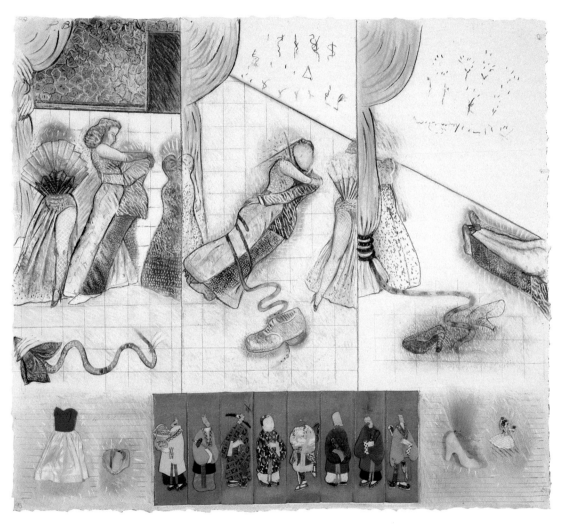

*Still and Not So Still Lives (Shoe),* 1977, mixed media and collage on paper with objects, 43¾″ x 49″

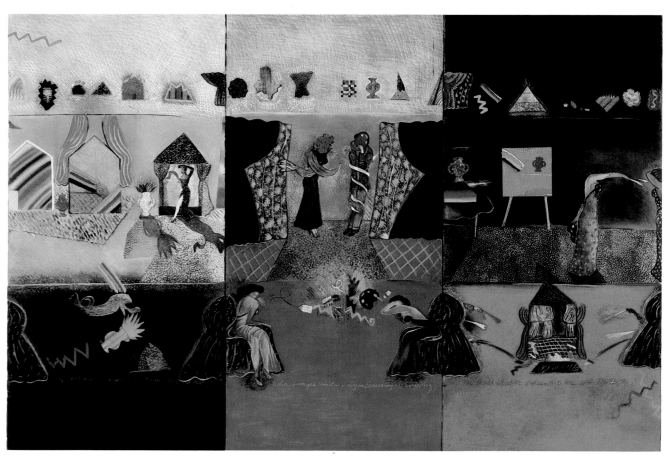

*Myths of Inspiration*, 1979, mixed media and collage on paper, 3 panels, each 73" x 36"

rier and is, to some extent, a presence and identity within the dramatic situations of the pictures. The expressive effect is more powerful and unified in them and the artist's emotional concerns are greatly clarified and more compelling than before.

What, exactly, *are* Bramson's themes and subjects? It has already been noted that she feels that her content is the exploration of the situation and nature of her own artistic identity, but this is a rather general formulation. More specifically, she has indicated that in her paintings (and other works) she has learned to live with states of feeling, dreams, wishes and a host of internal (and external) concerns that would be impossible, intolerable, impermissible, undesirable or just plain inconvenient in any other form or mode of existence. This emotional life of the artistic persona which necessarily is part of or at least within the life of the artist as a total person, Bramson has described as risky, saying that she feels "the danger of dealing with psychological states that are not possible otherwise [than in art]." Her task, she has said, is "trying to keep balanced."

Bramson's works are not merely illustrations of extravagant fantasy existences — although the world she presents is certainly full of high color and feeling, exotic personages, complex emotional and ritual interchanges and personal allegories of the metaphysics of the artist's life and work. And, it is true that some of her earlier drawings and pastels seem to be recollections of fragments of an existence glimpsed in dreams and imagination. (This allusive kind of imagery is most pronounced in the divided field compositions described above.) Since 1979-80, the artist has, with growing assurance, more fully revealed the nature of the emotional world within herself and of which she also is a part: as observers, we no longer are looking at pictures Bramson has drawn of her inner world but more and more are ourselves drawn into the dramas and rituals of this world. And, after all, if Bramson's images were not is some way germane to our own sense of existence — emotional and "actual" — how would it be possible for them to induce in us their undoubted affect? As she has built and clarified her own imagistic world, we find it has an increasing relevance to our own experience of similar concerns. Bramson has firmly plugged into some essential aspects of human identity and experience.

The particulars of Bramson's visions are exotic and theatrical: her figures are given costumes and accoutrements which are important means in suggesting their roles and emotional valences. These personages are sirens and shamans, acrobats and sailors, dandies, spivs and smoldering fire ships. That these beings are

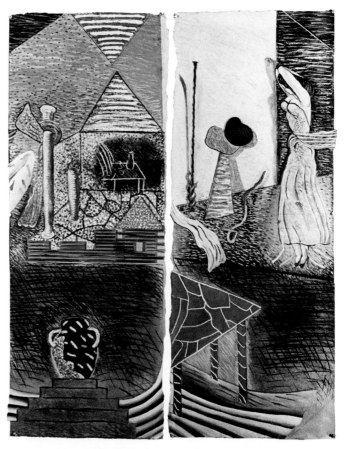

*Borrowing from Hockney (but Rejecting His Embrace) Stage 2*, 1980, mixed media and collage on paper, 49" x 40"

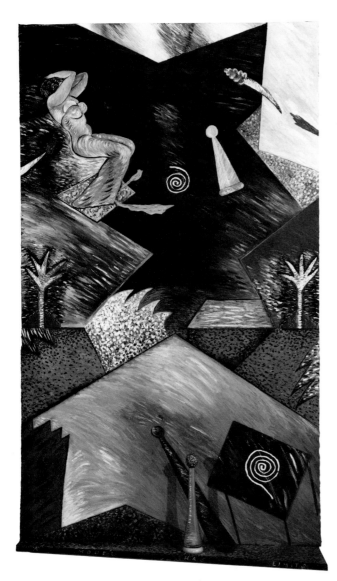

*A Model Has Limits,* 1981, oil on canvas and wood with collage, 61" x 36" x 6½"

characters and not caricatures is a tribute to both the artist's taste in inventing them and to the authenticity of the feelings with which she invests their relationships. In creating "cast of characters," any artist runs the risk of falling into a mannered artificiality which can only indicate or allude to various emotive states, not embody and express them. If Bramson's pictures are a kind of theater, it is a theater of improvisation and not truly narrative: in this respect, Bramson's "dramatic content" is rather like that of Max Beckmann or the strange world of H.C. Westermann's watercolors.

The space in which these figures are set in Bramson's work is, despite its involvement with depth and atmosphere, an abstracted space projecting a convincing sense of reality even if it is not "realistic." The same is true of her very high color, which, while arbitrary in the extreme, seems appropriate and even necessary to the emotional articulation of the subjects.

Bramson's subjects are poetic in nature, and she has a gift for poetically allusive titles (*Portrayals and Betrayals,* 1982, *Secrets Have Shadows,* 1984). Her figures confront one another as they balance on spheres, are doubled backwards in athletic and acrobatic contortions, glare at one another with erotic intensity, loll about in sensuous indulgence, and participate in inexplicable actions which appear to be rituals or ceremonies. While all these situations may be clearly depicted, their exact significance is a matter of multiple possibilities: are the "rituals" life and death confrontations, or a cooperative magical exercise? Are the couples lovers, antagonists, or both? The varying possibilities of each subject form chords of feeling and significance in which the separate tones are experienced together: the richness of the allusive possibilities here is just what the artist is after and in this connection it should not be surprising to learn that she regards the intricately layered meanings and allusions in the paintings of Robert Barnes as of the greatest interest and value.

In fact, mention of some of the artists who Bramson regards as influences and mentors — Philip Guston, Robert Barnes, James McGarrell, June Leaf, Maryan, Seymour Rosofsky, Hockney, Westermann, Blake, Breughel, Ensor, Redon, Magritte and Watteau — to list just a few, gives a good indication of the nature of the artistic experience she identifies with. These artists are largely painterly painters, with rich techniques and powerful senses of color, like Bramson herself. Other kinds of works of art she has mentioned as important to her vision and feeling are such things as Chinese, Japanese, and Indian erotic paintings, fifteenth-century Northern European art, the work of Ivan Albright,

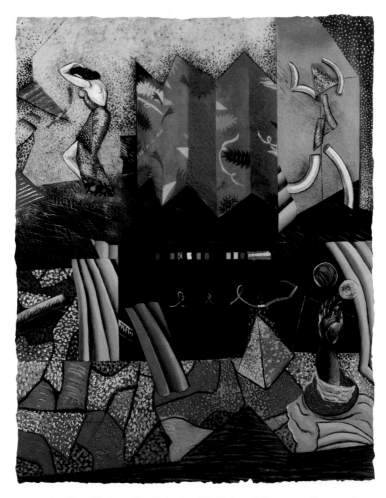

*Borrowing from Hockney (but Rejecting His Embrace) Stage 4*, 1980, mixed media and collage on paper, 49" x 40"

and a host of other imaginative and poetic visual statements of high intensity.

Bramson's precise stylistic locus is not easy to particularize since her development has not been smooth or predictably even; instead, she has proceeded in bursts of activity in different media before finally coming to painting alone (other than printmaking) as her *métier*. In many ways (the high color, organic forms, importance of linear elements, object-like qualities, schematic spaces) Bramson's work can be connected with the complex and varied phenomena referred to as Imagism and she speaks of her admiration for such artists as Jim Nutt, Roger Brown and Gladys Nilsson. However, Bramson has evolved a bit apart from these and other artists regarded as the most representative Imagists. In this regard, she can be seen as in a position rather like that of such other important artists as Paul

La Mantia and Robert Lostutter, to name but two. Bramson might also be seen as close in feeling and concerns to West Coast painters such as Joan Brown or even Nathan Olivera in their earlier work. However, the question of where Bramson "belongs" is of less significance than the specific nature of each of her artistic achievements: it is inevitable that any artist working in Chicago during the past twenty years and with Bramson's inclinations and temperament in some fashion reflect, partake of and even contribute to the vitality of the varied (and even irreconcilable) points of view regarded as Imagist. But like the Imagist artists themselves, Bramson sees her artistic context as wider than a single group of artists, a single place or even a single time. It is this broadness of scope and vision which keeps us eager to see what further richnesses her art will reveal in the future.

# Catalogue of the Exhibition

1.
*Carole Doll*, 1973
Mixed media
19" x 10" x 19"
Lent by Mr. and Mrs. Wilbur
Tuggle, Chicago

2.
*Margaret*, 1973
Mixed media
27" x 12" x 7"
Lent by Betsy Rosenfield, Chicago

3.
*Sleeping Self*, 1975
Mixed media on paper
50½" x 35"
Lent by Claire and Gordon Prussian,
Winnetka, IL

4.
*Baby Heidi Chair*, 1976
Mixed media
35" x 15" x 16"
Courtesy of Monique Knowlton
Gallery, New York

5.
*3 Stages of Night (Dusk, Twilight,
Night)*, 1976
Mixed media
21½" x 21½" x 15" each
Lent by the Hirshhorn Museum and
Sculpture Garden, Smithsonian
Institution, Washington, D.C.

6.
*Still and Not So Still Lives (Feather
Boa)*, 1977
Mixed media and collage on paper
with objects
43¾" x 49", shelf 8" x 26" x 5"
Lent by Dr. and Mrs. Jorge
Schneider, Highland Park, IL

7.
*Still and Not So Still Lives (Shoe)*, 1977
Mixed media and collage on paper
with objects
43¾" x 49", shelf 4" x 26" x 4¼"
Lent by Terri and Allan Sweig,
Highland Park, IL

8.
*Trapped (Childhood)*, 1977
Mixed media, collage and objects on
paper
40¾" x 26¾"
Lent by the artist, courtesy of
Monique Knowlton Gallery,
New York

9.
*Trapped (Lady)*, 1977
Mixed media, collage and objects on
paper
40¾" x 26¾"
Lent by Naomi and Martin Rubin,
Wilmette, IL

10.
*Fall of Eve 2*, 1979
Mixed media with objects on paper
47" x 41"
Lent by Susan Bush and Warren
Saks, New York

11.
*Myths of Inspiration*, 1979
Mixed media and collage on paper
3 panels, each 73" x 36"
Lent by Monique Knowlton,
New York

12.
*Borrowing from Hockney (but Rejecting
His Embrace) Stage 2*, 1980
Mixed media and collage on paper
49" x 40"
Lent by Daniel and Rena Sternberg,
Glencoe, IL

13.
*Borrowing from Hockney (but Rejecting
His Embrace) Stage 4*, 1980
Mixed media and collage on paper
49" x 40"
Lent by Kemper Group, Long
Grove, IL

14.
*13 Ways to Live 8 Ways Chosen (Con-
stant Seeking and Devotion)*, 1980
Mixed media and collage on paper
54" x 20"
Lent by Marsha Fogel, New York

15.
*13 Ways to Live 8 Ways Chosen (Taking
over the cast-off props)*, 1980
Mixed media and collage on paper
54" x 20"
Private Collection, New York

16.
*In Support of Trivial Novelties/Strain-
ing After New Effects*, 1980-81
Mixed media and collage on paper
73" x 37"
Lent by the artist

17.
*In Support of Trivial Novelties/The
Struggling Painter*, 1980-81
Mixed media and collage on paper
73" x 37"
Lent by the artist

18.
*A Model Has Limits*, 1981
Oil on canvas and wood with collage
61" x 36" x 6½"
Lent by Dr. and Mrs. Alan Ravitz,
Chicago

19.
*Rite of Staying Power, The Supporter*,
1981
Mixed media and collage on paper
62" x 40½"
Lent by S. Ronald Stone, courtesy
of Dart Gallery, Inc., Chicago

20.
*Rite of Staying Power, Yellow Fighter*,
1981
Mixed media and collage on paper
62" x 40½"
Lent by Mr. and Mrs. Lee Hill,
Chicago

21.
*Testing Acts of Will (Snake Charmer)*,
1981
Mixed media
Two panels, each 24¼" x 41"
Figure with base 51" x 10" x 10"
Lent by the artist, courtesy of Dart
Gallery, Inc., Chicago

22.
*The Existentialist Witness (for P.
Adams) Stage 2*, 1982
Oil and collage on canvas
61¾" x 73" x 3½"
Lent by Maria Bechily-Hodes,
Chicago

23.
*Portrayals and Betrayals Stage 1*, 1982
Oil and collage on canvas
73" x 61" x 3"
Lent by the artist, courtesy of Dart
Gallery, Inc., Chicago

24.
*Portrayals and Betrayals Stage 2*, 1982
Oil and collage on canvas
73" x 61" x 3"
Lent by the artist, courtesy of Dart
Gallery, Inc., Chicago

25.
*Innocent Diversions*, 1983-84
Oil and collage on canvas with
objects
60" x 72"
Lent by the Illinois Collection, State
of Illinois Center, Chicago

26.
*Secrets Have Shadows*, 1984
Oil and collage on canvas with
objects
Two panels, each 72" x 49"
Courtesy of Monique Knowlton
Gallery, New York

27.
*Acts of Ardor 3*, 1984
Oil on canvas
60¾" x 72"
Lent by Mrs. Barbara Becker,
Northbrook , IL

28.
*The Dance*, 1985
Oil on canvas
67¾" x 97"
Lent by the artist, courtesy of
Monique Knowlton Gallery,
New York

29.
*Pink Nude on Cone, Sphere and Cube*,
1985
Oil on canvas
72½" x 60½"
Lent by the artist, courtesy of Dart
Gallery, Inc., Chicago

30.
*Shaking Still*, 1985
Oil on canvas
97" x 69"
Lent by the artist, courtesy of Dart
Gallery, Inc., Chicago

31.
*States of War, Seige 1*, 1985
Oil on canvas
Two panels, each 72" x 49"
Lent by Terri and Allan Sweig,
Highland Park, IL

32.
*Shipwrecked*, 1986
Oil on canvas
67¾" x 96¾"
Lent by the artist, courtesy of
Monique Knowlton Gallery,
New York

33.
*Trouble A-Head*, 1986
Oil on canvas
72¾" x 60½"
Lent by Lee Wesley and Victoria
Granacki, Chicago

# Biography

Born: 1941, Madison, Wisconsin
Studied: University of Illinois, Urbana, Illinois BFA
1963; University of Wisconsin, Madison, Wisconsin,
MA 1964; School of the Art Institute of Chicago,
Chicago, Illinois, MFA 1973

## One Person Exhibitions

1985 *Paintings and Drawings 1982-1984.* Hewlett Gallery, Carnegie-Mellon University, Pittsburgh, Pennsylvania.

Joseph Gross Gallery, University of Arizona, Tucson, Arizona.

Dart Gallery, Chicago, Illinois.

1984 Monique Knowlton Gallery, New York, New York.

Siegfried Gallery, University of Ohio, Athens, Ohio.

1983 Dart Gallery, Chicago, Illinois.

Marilyn Butler Gallery, Scottsdale, Arizona.

1982 Monique Knowlton Gallery, New York, New York.

1981 Monique Knowlton Gallery, New York, New York.

1980 Galerie Farideh Cadot, Paris, France.

Dart Gallery, Chicago, Illinois.

1979 Monique Knowlton Gallery, New York, New York.

1978 Marianne Deson Gallery, Chicago, Illinois.

1977 Monique Knowlton Gallery, New York, New York.

1976 Artemisia Gallery, Chicago, Illinois.

1973 Illinois Arts Council Gallery, Chicago, Illinois.

## Group Exhibitions

1986 *Intimate/Intimāte,* Turman Gallery, Indiana State University, Terre Haute, Indiana.

*Work on Paper from the Kemper Group Art Collection,* Suburban Fine Arts Center, Highland Park, Illinois.

1985 *Contemporary Woodcuts,* Brody's Gallery, Washington, D.C.

*The Doll Show: Artists' Dolls and Figurines,* Highwood Art Gallery, Long Island University, Greenvale, New York.

*Drawings as Contemporary Icon,* Brody's Gallery, Washington, D.C.

*81st Exhibition by Artists of Chicago and Vicinity,* The Art Institute of Chicago, Chicago, Illinois.

*The Figure in Chicago Art,* The Museum of Contemporary Art, Chicago, Illinois.

*Looking at Men,* Artemisia Gallery, Chicago, Illinois.

*Self Portraits,* Security Pacific National Bank Gallery, Los Angeles, California.

*Shadow,* N.A.M.E. Gallery, Chicago, Illinois.

*States of War/New European and American Painting,* Seattle Art Museum, Seattle, Washington.

*Then and Now,* Hyde Part Art Center, Chicago, Illinois.

*20th Bradley National Print and Drawing Exhibition,* Lakeside Museum of Art and Science, Peoria, Illinois.

Fiona Whitney Gallery, Los Angeles, California.

1984 *Alternative Spaces: A History in Chicago,* The Museum of Contemporary Art, Chicago, Illinois.

*Chicago Cross-Section,* Trisolini Gallery, Ohio University, Athens, Ohio.

*80th Exhibition by Artists of Chicago and Vicinity,* The Art Institute of Chicago, The Campana Prize, Chicago, Illinois.

*The Finals in Painting and Sculpture,* Jan Baum Gallery, Los Angeles, California.

*The Head Show,* Randolph Street Gallery, Chicago, Illinois.

*Midwest Invitational Exhibition,* Clark Arts Center, Rockford College, Rockford, Illinois.

*Sixtieth Annual International Competition,* The Print Club, Pittsburgh, Pennsylvania.

*Ten Years/1973-1983,* Artemisia Gallery, Chicago, Illinois.

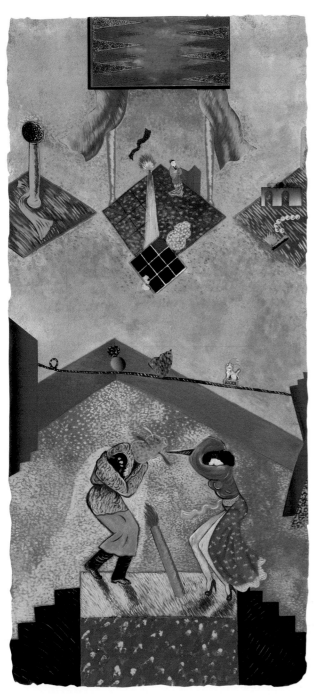

*In Support of Trivial Novelties/The Struggling Painter*, 1980-81, mixed media and collage on paper, 73" x 37"

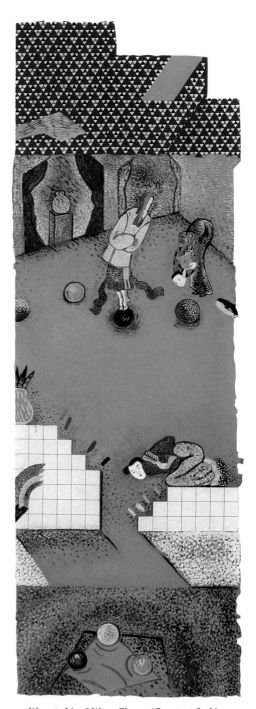

*13 Ways to Live 8 Ways Chosen (Constant Seeking and Devotion)*, 1980, mixed media and collage on paper, 54" x 20"

1983 *The Big Picture/20 Years of Abstraction in Chicago*, Hyde Park Art Center, Chicago, Illinois.

*Chicago Scene*, Manville Gallery, University of California-San Diego, La Jolla, California.

*Chicago/Some Other Traditions*, Madison Art Center, Madison, Wisconsin.

*Contemporary Chicago Lithography*, Illinois State Museum, Springfield, Illinois.

*The Figurative Mode: Recent Drawings from New York Galleries*, Dowd Fine Arts Center, State University of New York, Cortland, New York.

*Intoxication*, Monique Knowlton Gallery, New York, New York.

*New Acquisitions*, Musee de Toulon, Toulon, France.

*New Editions*, Landfall Press, Chicago, Illinois.

*Prints by Women*, Penn's Landing Museum, Philadelphia, Pennsylvania.

1982 *Douglas Drake Presents Chicago*, Douglas Drake, Kansas City, Missouri.

*Invitational Exhibition*, Illinois State Museum, Springfield, Illinois.

*Painting Today*, Indianapolis Museum of Art, Indianapolis, Indiana.

*Recent Acquisitions to the Permanent Collection*, The

1981 *Chicago Show*, Lynn Plotkin Gallery, St. Louis, Missouri.

*Collector's Choice*, Lochhaven Art Center, Orlando, Florida.

*79th Exhibition by Artists of Chicago and Vicinity*, The Art Institute of Chicago, Chicago, Illinois. Travelled to: National Academy of Design, New York, New York; National Museum of American Art, Washington, D.C.; Illinois State Museum, Springfield, Illinois.

1980 *Chicago*, Galerie Farideh Cadot, Paris, France.

*Chicago/Chicago*, Contemporary Art Center, Cincinnati, Ohio.

*Interiors*, Barbara Gladstone Gallery, New York, New York.

*Phyllis Bramson and Galen Hanson*, University Galleries, University of South Florida, Tampa, Florida.

*78th Exhibition by Artists of Chicago and Vicinity*, The Art Institute of Chicago, Chicago, Illinois.

*Touch Me*, N.A.M.E. Gallery, Chicago, Illinois.

1979 *Chicago Alternative*, Herron Gallery, Indiana University, Indianapolis, Indiana.

*Chicago Drawing*, Columbia College Gallery, Chicago, Illinois.

*Color in Sticks*, The Museum of Contemporary Art, Chicago, Illinois.

*Installation Drawings*, The New Museum of Contemporary Art, New York, New York.

*Narrative Imagery*, ARC Gallery, Chicago, Illinois.

1978 *Chicago Self Portrait*, Nancy Lurie Gallery, Chicago, Illinois.

*78: Drawing Invitational*, Illinois State University Gallery, Normal, Illinois.

*The Handmade Paper Object*, Williams College Museum of Art, Williamstown, Massachussetts.

*Traveling Papermakers Show*, SITES, Smithsonian Institution, Washington, D.C.

*Works on Paper*, The Art Institute of Chicago, Chicago, Illinois.

Hyde Park Art Center, Chicago, Illinois.

1977 *Figurative Painters in the Midwest*, Madison Art Center, Madison, Wisconsin.

*76th Exhibition by Artists of Chicago and Vicinity*, The Art Institute of Chicago, Chicago, Illinois.

1976 *New Talent*, Monique Knowlton Gallery, New York, New York.

*Object as Poet*, The Renwick Gallery, The Smithsonian Institution, Washington, D.C.

Rockford College, Rockford, Illinois.

1974 *Dolls for Adults*, Artemisia Gallery, Chicago, Illinois.

*Drawing Show*, Quincy College, Quincy, Illinois.

*Five Chicago Artists*, One Illinois Center, Chicago, Illinois.

*Invitational*, Coe College, Cedar Rapids, Iowa.

*Invitational*, Purdue-Indiana University, Fort Wayne, Indiana.

Madison Art Center, Madison, Wisconsin.

*New Horizons '75*, Chicago, Illinois.

1973 *Art in Chicago: Emerging Vantage Points*, Loop College, Chicago, Illinois.

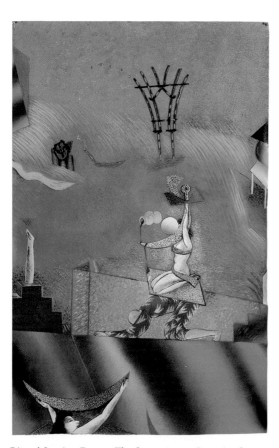

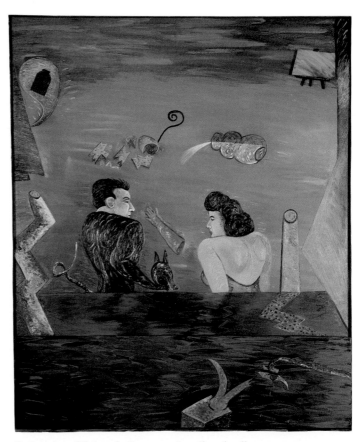

*Rite of Staying Power, The Supporter,* 1981, mixed
media and collage on paper, 62" x 40½"

*Portrayals and Betrayals Stage 1,* 1982, oil and collage on canvas,
73" x 61" x 3"

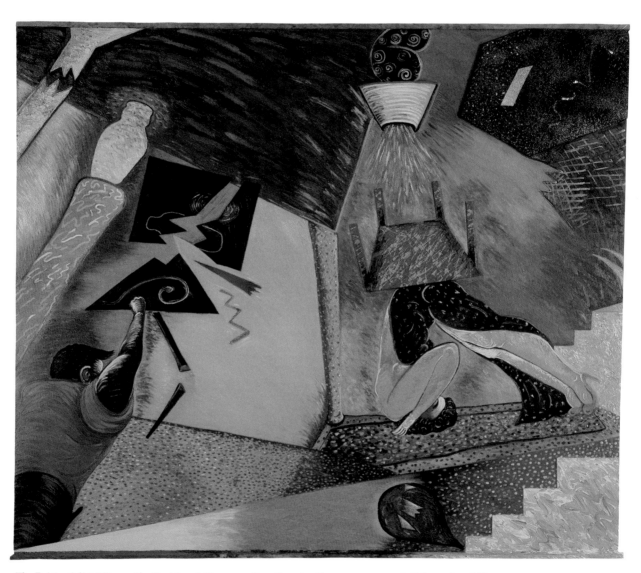

*The Existentialist Witness (for P. Adams) Stage 2*, 1982, oil and collage on canvas, 61¾″ x 73″ x 3½″

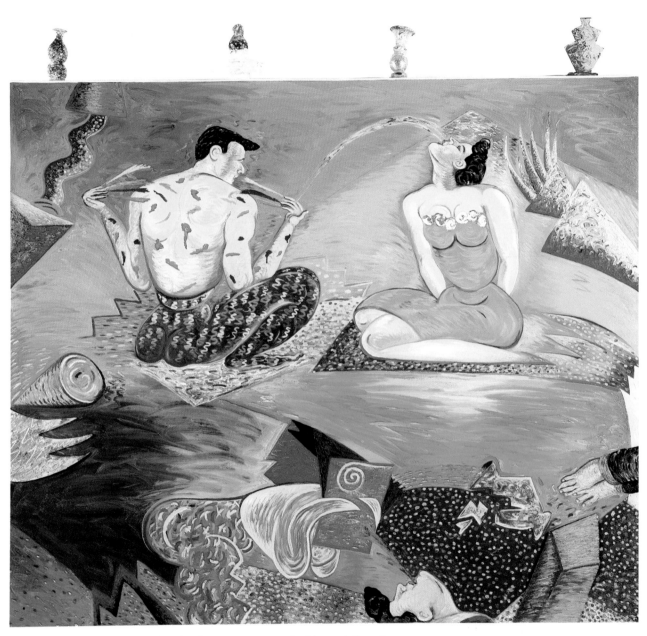

*Innocent Diversions*, 1983-84, oil and collage on canvas with objects, 60" x 72"

# Selected Bibliography

**Catalogue Essays**

Adrian, Dennis. "Phyllis Bramson." in Madison, Wisconsin, The Madison Art Center. *Chicago/Some Other Traditions.* October 2 - November 25, 1983: 12-15.

Chicago, ARC Gallery. *Narrative Imagery.* February 4 - March 4, 1979: 12-13.

Chicago, Artemisia Gallery. *Artemisia 10 Years/1972–1983.* June, 1984: 26.

Cincinnati, Contemporary Art Center. *Chicago/Chicago.* October 3 - November 9, 1980: 6.

Evans, Robert. "Untitled." in Springfield, Illinois, Illinois State Museum, *34th Illinois Invitational.* 1983.

Frueh, Joanna. "Touch Me." in Chicago, N.A.M.E. Gallery. *Touch Me.* February 1-23, 1980: 15.

Guenther, Bruce. "States of War." in Seattle, Seattle Art Museum. *States of War/New European and American Painting.* April 18-June 23, 1985: 10, 28-29.

Indianapolis, Herron Gallery. *Chicago Alternative.* 1980.

Jacobs, Mary Jane. "Phyllis Bramson." in Los Angeles, Gallery at the Plaza, Security National Bank. *Self Portraits by Women Artists.* January 26 - April 27, 1985: 14-15, 36.

King, Elaine. "Phyllis Bramson: Enigmatic Tableaux." in Pittsburgh, Hewlett Gallery, Carnegie-Mellon University. *Phyllis Bramson: Paintings and Drawings 1982-1984,* January 6-31, 1985: 8-11.

Logan, Susan. "Phyllis Bramson:" in New York, The New Museum of Contemporary Art. *In a Pictorial Framework.* August 28 - September 15, 1979: 32-49.

Madison, Madison Art Center and The University of Wisconsin. *New American Graphics 2.* March 13 - April 25, 1982: 24.

Normal, Illinois, Visual Arts Gallery, Illinois State University. *Illinois Artists 78 — A Drawing Invitational.* 1978: 6-7.

Peoria, Illinois, Lakeside Museum. *20th Bradley National Print and Drawing Exhibition.* February 16 - March 17, 1985: 8-9.

Philadelphia, Penns Landing Museum. *National Exhibition of Prints and Photographs by Women.* February 17 - March 27, 1983: 21.

Ratcliff, Carter. "Phyllis Bramson." in New York, Monique Knowlton Gallery. *Narrative Painting.* April 4 - May 2, 1981: 3, 7, 8.

Robertson, Joan. "Phyllis Bramson." in Long Grove, Illinois, Kemper Insurance Co. *Kemper Art Collection.* 1981.

Saliga, Pauline. "Phyllis Bramson." in Chicago, Museum of Contemporary Art. *Color in Sticks.* June 5 - August 5, 1979.

Washington, D.C., Renwick Gallery, Smithsonian Institution. *The Object as Poet.* December 15, 1976 - June 26, 1977: 27.

Greenvale, New York, Hillwood Art Gallery, Long Island University. *The Doll Show/Artists Dolls and Figurines.* December 11, 1985 - January 9, 1986: 18.

**Reviews and Articles**

Adrian, Dennis. "Drawing in Chicago, The Second Wave." *Drawing* 4 (January/February 1983): 105-109.

Artner, Alan. "Phyllis Bramson at Artemisia." *The Chicago Tribune,* Tempo, May 23, 1975: 10.

Bouras, Harry. "Phyllis Bramson at Artemisia." WFMT Radio, Critic's Choice, June 13, 1976.

Dudar, Helen. "French Revolutionary: How Modern Art Came to Toulon's Art Museum." *Connoisseur* 213 (May/August 1983): 26.

Frueh, Joanna. "Crucibles of Beauty- Occult Symbolism of Seven Chicago Women." *New Art Examiner* 8 (November 1980): 4-S.

_____ . "The Personal Imperative - Post Imagist Art in Chicago." *New Art Examiner* 6 (October 1978): 4-S.

_____ . "Phyllis Bramson at Monique Knowlton and The New Museum." *Art in America* 68 (January 1980): 112-113.

_____ . "Sexuality in Art." *New Art Examiner* 6 (Summer 1979):1.

Gerrit, Henry. "Phyllis Bramson." *Art News* 80 (September 1981).

Glatt, Cara. "Show Fans Old Center Spirit." *Hyde Park Herald,* October 12, 1983: 17.

Hanson, Henry. "Art in Chicago." *Chicago Magazine* (May 1984): 120, 174.

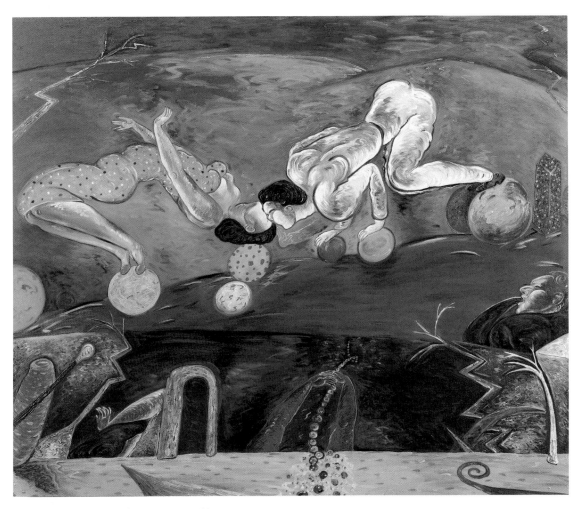

*Acts of Ardor 3*, 1984, oil on canvas, 60¾" x 72"

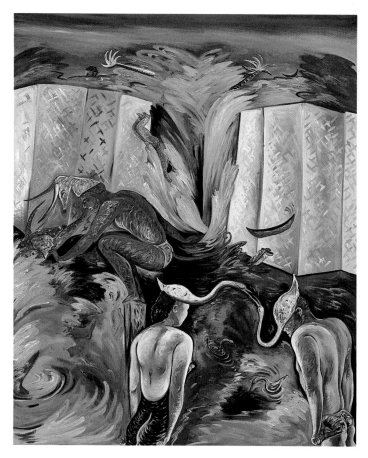

*Trouble A-head*, 1986, oil on canvas, 72¾" x 60½"

Larson, Kay. "Imperialism with a Grain of Salt." *Village Voice*, September 17, 1979.

_____ . "Phyllis Bramson." *Village Voice*, April 15, 1981.

_____ ."Primal Dreams." *New York Magazine*, March 26, 1984: 26.

Lyon, Christopher. "Hyde Park Show Fuels Interest in Figurative Art." *Chicago Sun Times*, February 4, 1982.

_____ . "MCA Show Strains to Support Artists vs. Establishment Thesis." *Chicago Sun-Times*, July 1, 1984: 19.

_____ . "10 Years of Growth, Women's Art a Major Force." *Chicago Sun-Times*, July 6, 1984: 43.

Morrison, C.L. "Phyllis Bramson at Marianne Deson Gallery." *Artforum* 16 (April 1978): 72-73.

Moufarrege, Nicolas A. "Intoxication." *Arts Magazine* 57 (April 1983): 72-75.

Naisse, A. "Phyllis Bramson at Monique Knowlton." *Craft Horizons Magazine*, (1976).

Peters, Lisa Nichol. "Phyllis Bramson." *Arts Magazine* 56 (April 1982): 9.

Pincus, Robert L. "Putting themselves into the real picture." *Los Angeles Times*, Part V, February 2, 1985: 3.

Rickey, Carrie. "Chicago." *Art in America* 66 (July/August 1978): 46-56.

_____ ."Put the Blame on Boys, Mame." *Village Voice*, November 2, 1982.

Russel, John. "Phyllis Bramson at Monique Knowlton." *New York Times*, March 12, 1982.

Schulze, Franz. "Elsewhere at the MCA." *Chicago Sun-Times*, July 8, 1979: 7.

Tully, Judd. "Manhattan Art Dealers Raid Chicago." *New Art Examiner* 8 (May 1981): 1.

Welzenbach, Michael. "Brody shows art of three cities." *Washington Times*, December 12, 1985: 38.

Zimmer, William. "New Wavering." *Soho Weekly News*, September 15, 1979.

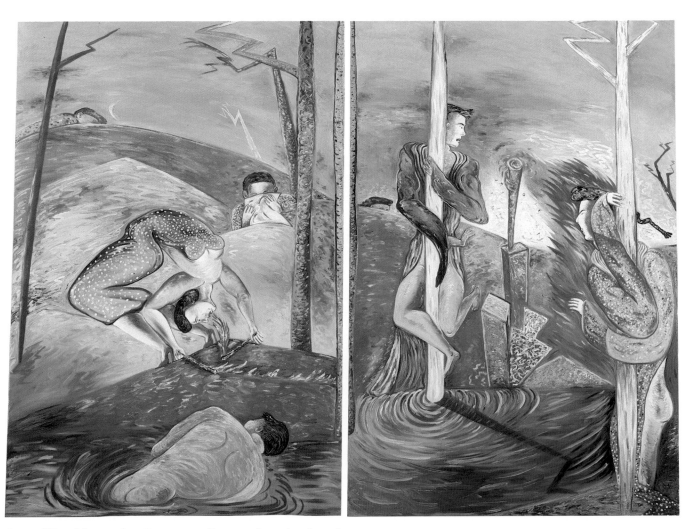

*States of War, Seige 1*, 1985, oil on canvas, Two panels, each 72" x 49"

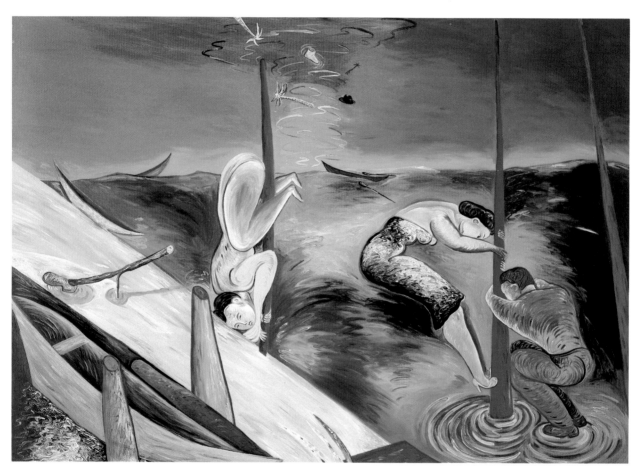

*Shipwrecked*, 1986, oil on canvas, 67¾" x 96¾"

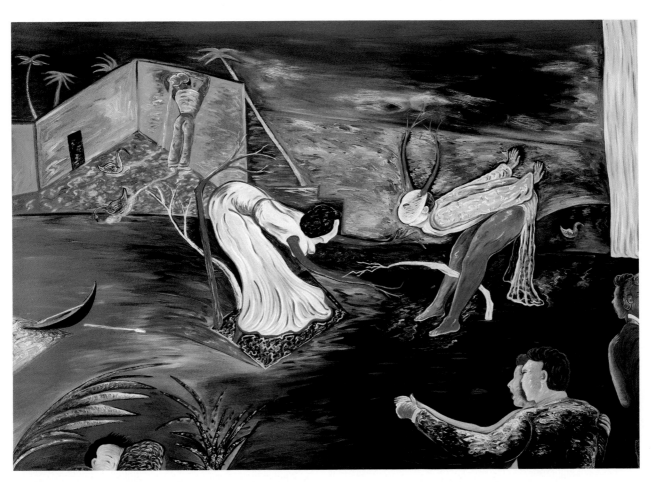

*The Dance*, 1985, oil on canvas, 67¾″ x 97″